Looking at
Prints, Drawings and Watercolours

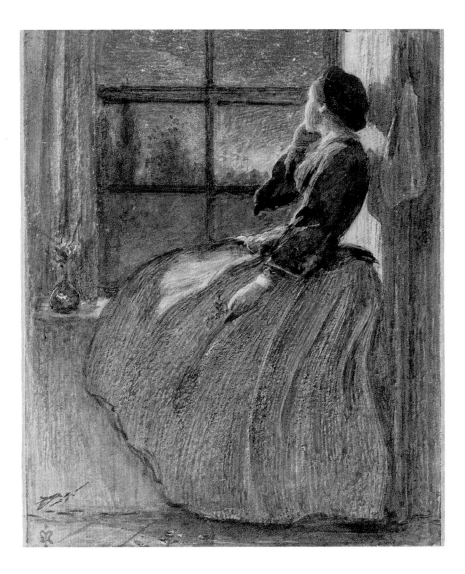

Looking at Prints, Drawings and Watercolours

A Guide to Technical Terms

Paul Goldman

THE BRITISH MUSEUM PRESS

in association with the J. Paul Getty Museum, Los Angeles

© 1988, 2006 The Trustees of the British Museum

Published by The British Museum Press
A division of The British Museum Company Ltd
38 Russell Square, London WC1B 3QQ
www.britishmuseum.co.uk

in association with
Getty Publications
1200 Getty Center Drive, Suite 500
Los Angeles, California 90049-1682
www.getty.edu

Mark Greenberg, *Editor in Chief*

Second Edition

Ownership of the illustrations is indicated in the captions
by the initials BM (British Museum) or JPGM (J. Paul Getty Museum).
Except where stated below, images are copyrighted by the same institutions.

The publishers are grateful to the following for permission to reproduce
their images: Page 27 The Henry Moore Foundation; page 29 © Richard
Hamilton; page 44 © Sybil Andrews; page 45 © ADAGP, Paris and DACS,
London 2006; page 59 © Successio Miró/ADAGP, Paris and DACS,
London 2006; page 64 © DACS, London/Vaga, New York 2006;
page 72 © Frederick Warne & Co. 2006.

Library of Congress Cataloging-in-Publication Data
Goldman, Paul.
 Looking at prints, drawings and watercolours
 : a guide to technical terms.
 1. Graphic arts. Terminology
 I. Title II. British Museum III. J. Paul
 Getty Museum
 760´.014

 ISBN 13: 978-0-89236-871-6
 ISBN 10: 0-89236-871-3

Designed and typeset by John Hawkins

Printed in China by C&C Offset Printing Co. Ltd

Front Cover: Pierre-Paul Prud'hon (French, 1758–1823), *Study of a Female Nude, c.* 1800. Black and white chalk, stumped, on blue paper, 60.4 × 31.8 cm (23 ¾ × 12 ½ in.). JPGM 99.GB.49.

Frontispiece: John Everett Millais (English, 1829–1896), *Lost Love*, 1859. Watercolour and bodycolour with gum arabic, 103 × 85 mm (4 1/16 × 3 3/8 in). BM 1937-4-10-3.

Back Cover: Paul Cézanne (French, 1839–1906), *Still Life with Blue Pot* (detail), *c.* 1900–1906. Watercolour and graphite, 480 × 631 mm (18 15/16 × 24 7/8 in). JPGM 83.GC.221.

Contents

Foreword

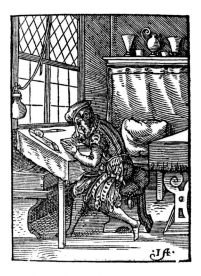

Jost Amman (1539–91): *The Woodcutter*, 1568. Woodcut, 79 × 59 mm (3⅛ × 2⁵⁄₁₆ in). BM, 159.d.II, 1904–2–6–103(19).

Many art-historians and museum curators assume, often wrongly, that the terms which they routinely employ to describe prints, drawings and watercolours are readily understood by most visitors to exhibitions and readers of catalogues. Accurate definitions of these terms are regularly difficult to find in reference books, and the aim of this publication is therefore to bring together many of the most commonly found ones and attempt to clarify their meanings. The first edition of this book grew out of two previous publications by the author, *Looking at Drawings* (1979) and *Looking at Prints* (1981), both now long out of print. While this is more ambitious in scale, the purpose remains identical: to be as accurate as possible within the confines of space.

The book is aimed at the person looking at traditional collections of prints, drawings and watercolours and hence deals only briefly with photomechanical processes and some of the most recent developments in original printmaking. However, in this new edition the opportunity has been taken to increase the number of photographs and include more colour, to add entries on digital printmaking, copies, reproductions and fakes and an appendix on the care of works on paper. The bibliography has been revised and an index provided.

Colleagues in the Department of Prints and Drawings at the British Museum helped me enormously over the first edition. They were Antony Griffiths, Nicholas Turner, Lindsay Stainton, Martin Royalton-Kisch, Frances Carey, Eric Harding and Alan Donnithorne. For the new edition I wish to thank Antony Griffiths once again, Stephen Coppel, and Teresa Francis, my meticulous and patient editor at BMP both in 1988 and again today.

Note
Words printed in SMALL CAPITALS refer to other entries in the book. Terms which do not have separate entries are in inverted commas.

AQUATINT

A variety of ETCHING and essentially a tone process which can be used to imitate the appearance of watercolour washes. The chief element of the process, which was invented in France in the 1760s, is the partial protection of the surface of the plate with a porous ground through which the acid can penetrate. The plate is covered with a ground of powdered resin which is attached to the plate by heating. In etching, the acid bites tiny rings around each resin grain, and these hold sufficient ink when printed to give the effect of a wash. The printmaker will 'stop out' with a protecting varnish any parts of the ground where he wishes to obtain pure white. Gradations of tone can be achieved by careful repetition of the biting and varnishing process or by burnishing. This has the disadvantage of being a 'negative' process, since the 'stopped-out' areas remain white.

An alternative 'positive' process is 'sugar' or 'lift-ground' aquatint. The plate is covered in resin as in ordinary aquatint and the artist draws on the surface in a solution of sugar and water. A varnish is then

AQUATINT Enlarged detail.

laid over the entire plate, which is then immersed in water. This causes the sugar under the varnish to swell and lift, exposing the aquatint ground; the plate is then bitten and printed in the normal way.

Artist's proof
In twentieth-century and contemporary printmaking, an artist's proof is an impression signed by the artist and annotated 'AP' (or something similar) which is extra to the ordinary numbered edition. The practice of signing PROOFS began, however, in the nineteenth century.

Ascribed
A drawing is 'ascribed' to an artist when it has been given to him by tradition, most frequently by an INSCRIPTION on the drawing or on its mount. The term, however, suggests some doubt in the mind of the cataloguer as to the correctness of this tradition.

Attributed
A drawing is 'attributed' to an artist on the grounds of style or some good external evidence; however, some doubt remains about its authorship.

Baxter print
In 1835, George Baxter patented a printing technique under his own name. It involved overprinting an INTAGLIO key-plate with numerous wood or metal

Baxter print
George Baxter (1804–67): *Gems of the Great Exhibition No. 2*, 1852.
Baxter print, 120 × 241 mm (4¾ × 9½ in). BM, 1901–11–5–20.

blocks inked in oil colours. The technique was used by others under licence from Baxter, most notably by Le Blond, and fell into disuse after 1865. (See C. T. Courtney Lewis, *George Baxter the Picture Printer*, London, 1924.)

BODYCOLOUR

Any type of opaque water-soluble pigment. At an early period the opaque medium employed was lead white. In 1834 Winsor and Newton introduced Chinese White, which is zinc oxide, and this was marketed as a substitute for lead white.

The bodycolour medium was known in the late fifteenth century when Dürer made drawings of landscapes, animals and flowers in a combination of bodycolour and watercolour. Later artists such as Rubens and Van Dyck also made extensive use of bodycolour, but it reached its greatest popularity in the 1820s and 1830s in England when watercolourists, most notably Turner, exploited it to the full, combining the opacity of the lights with the transparency of the washes of colour. Sometimes they executed works in bodycolour alone. Drawings loosely termed 'watercolours' are frequently found to be done in a combination of transparent pigments with opaque ones. See also TEMPERA, WATERCOLOUR, GOUACHE and HEIGHTENING.

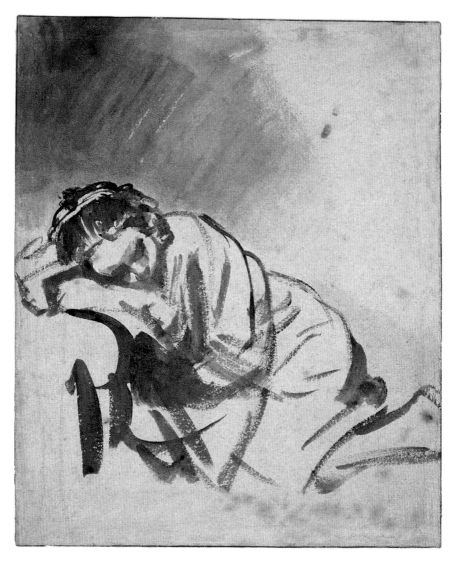

BRUSH DRAWING
Rembrandt van Rijn (1606–69): *A Girl Sleeping (Hendrickje Stoffels?)*.
Brush drawing in brown ink, 245 × 203 mm (9⅝ × 8¹⁄₁₆ in). BM, 1895-9-15-1279.

BRUSH

Brushes have been used for drawing since ancient times. From the medieval period brushes were fine and pointed and were made usually of squirrel hair fixed into the tapered ends of quills. Many drawings described as having been executed in pen are often found on closer examination to have been drawn with a fine brush.

CAMERA OBSCURA AND LUCIDA

The *camera obscura* was an optical apparatus consisting of a darkened chamber, at the top of which was placed a box or lantern containing a convex lens and a sloping mirror. The view passed through the lens and was reflected by the mirror onto a sheet of paper placed at the bottom of the box. In this way a three-dimensional view was reduced to a two-dimensional image, which could be traced or otherwise used to help the artist reproduce the view accurately. The apparatus was first mentioned by the German astronomer Johann Kepler in the first decade of the seventeenth century, but the principles behind its use were described in Chinese texts of the fifth century BC. (See J. Hammond, *The Camera Obscura – A Chronicle*, Bristol, 1981.)

The *camera lucida* was a development from the *camera obscura*. It consisted of a glass prism mounted on the end of an adjustable arm. It was an awkward instrument to use because the operator's eye had to be placed so that the centre of the pupil was directly above the edge of the prism. A reflection of the view or object was seen in the prism by half the eye and the point of the drawing instrument by the other half. As the images merged on the retina, the outline of the reflection could be traced. It was invented at the beginning of the nineteenth century by Dr William Hyde Wollaston for drawing in perspective. (See J. Hammond and J. Austin, *The Camera Lucida in Art and Science*, Bristol, 1987.)

CARTOON

A drawing of the principal forms of a composition, made to the same scale as the painting or FRESCO for which it is preparatory. For some frescoes the cartoon was applied in sections to the wall and the outlines cut through on the wet plaster, destroying the cartoon in the process. The cartoon was sometimes preserved by TRANSFERRING its design onto a secondary cartoon, a sheet of paper placed beneath the first, by pricking (see POUNCE) or indenting it with a STYLUS. This secondary cartoon would be placed on the wall.

Examples of cartoons in the British Museum collection are the *Epifania* by Michelangelo (which is apparently neither pricked nor indented) and the *Virgin and Child* by Raphael which was used for the so-called *Mackintosh Madonna* in the National Gallery, London (which is partly pricked and partly indented). The chalk dust rubbed through the perforations in the paper would also affect the appearance of a cartoon by causing a 'greying'; some small-scale cartoons were drawn in pen and ink, so the main outlines are still visible after this 'greying'. These are usually cartoons for paintings executed on wooden panels. Cartoons have also traditionally been used in the manufacture of tapestries and stained glass.

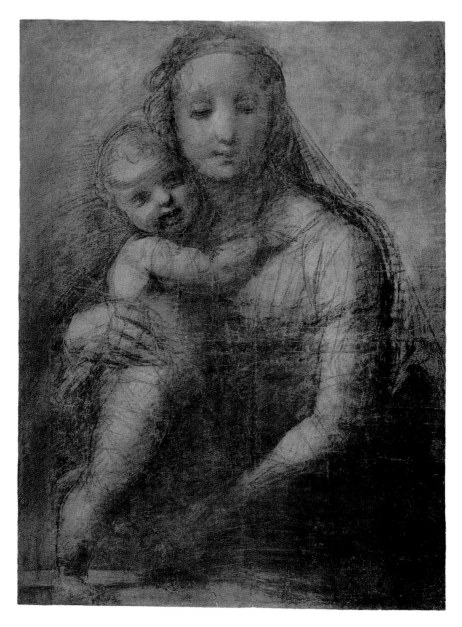

CARTOON

Raphael (Raffaello Santi, 1483–1520): *The Virgin and Child*.
Cartoon corresponding with the *Mackintosh Madonna*. Black chalk with some traces
of white heightening, 710 × 535 mm (27¹⁵⁄₁₆ × 21⅛ in). BM, 1894–7–21–1.

An 'auxiliary cartoon' is a term coined by the German art-historian Oskar Fischel to describe Raphael's practice of making subsidiary detailed studies based upon outlines traced through from the complete cartoon. Such details were of heads, hands, etc., which the artist wanted to realise with particular care. The drawings would have been kept close at hand as a guide when Raphael came to execute the corresponding passages in his painting.

The more frequent modern use of the word 'cartoon', remote from its original meaning, denotes a humorous or sarcastic representation of a current topic, frequently political. This usage dates from about 1843, when an exhibition was held in Westminster Hall of cartoons from which designs were to be selected for the fresco decoration of the new Houses of Parliament. *Punch* facetiously entered the competition with a composition by John Leech, and this was the first such drawing to be called a cartoon.

CHALK

1 Natural chalks

Natural chalks of various colours are derived from earths. Natural grey chalk is obtained from brick clay, natural red chalk from the red ochre variety of haematite, natural white chalk from the chalk variety of calcite or soapstone, and natural black chalk from carbonaceous shale. For drawing purposes, lumps of these materials were reduced in size and inserted into metal holders, and the drawing end was shaved to a point.

Red chalk was known by the sixteenth century and deposits were recorded in Italy, Spain, Flanders, France and Germany. Numerous Renaissance artists drew in red chalk, and Leonardo da Vinci, Michelangelo and Correggio were among the most distinguished exponents of the medium. These natural red chalks varied in colour according to differences in the natural compositions of the red ochre variety of haematites in different deposits. Variation in hue could also be obtained by wetting the chalk before application. 'Sanguine' is another term for red chalk which is often found in older references.

Black chalk appeared at about the same time as red chalk and was similarly mined throughout western Europe. By the late eighteenth and early nineteenth centuries, however, the use and importance of black chalk had declined, largely because its quality was variable, and it began to be replaced with fine black CRAYONS.

White chalk was known widely in Renaissance times, when it was primarily employed to HEIGHTEN drawings in other media. Because of its softness it was especially easy to shape into sticks or insert into holders.

A technique especially favoured by French artists of the eighteenth century,

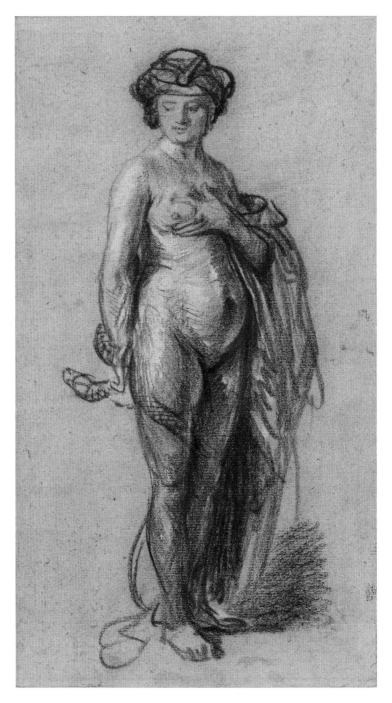

RED CHALK

Rembrandt van Rijn (1606–69): *Nude Woman with a Snake (as Cleopatra)*,
c.1637. Red and white chalk, 248 × 137 mm (9¾ × 5⅜ in). JPGM, 81.CB.27.

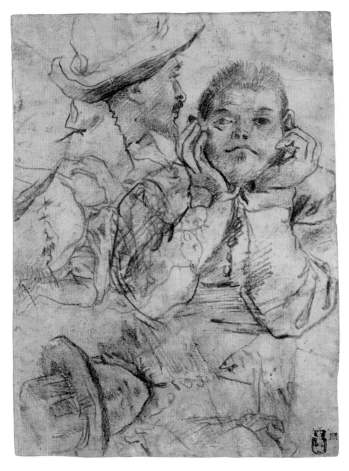

BLACK CHALK

Annibale Carracci (1560–1609): *Three Studies of Men* (*recto*), mid-1580s.
Black chalk, 277 × 207 mm (10⅞ × 8⅛ in). JPGM, 85.GB.218.

notably Watteau, was called '*aux trois crayons*'. It was a combination of red, black and white natural chalks, usually on a yellowish or off-white paper.

2 Fabricated chalks (Pastels)

Fabricated chalks or pastels are dry drawing media made from powdered pigments combined with non-greasy binders. They are used in the form of finger-length sticks. The marks made by pastels are opaque, and specially prepared papers, often tinted or ribbed, have been manufactured for pastel drawing since the eighteenth century. The colours may be mixed by smudging, using the fingers or a STUMP, or may be combined optically – a usage much favoured by Degas.

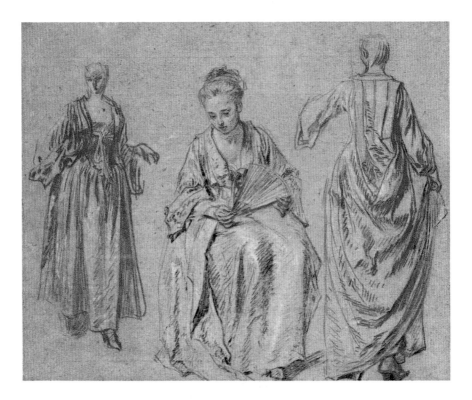

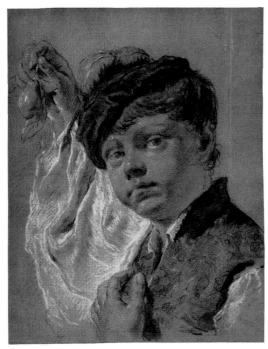

AUX TROIS CRAYONS
Jean Antoine Watteau (1684–1721):
*Studies of Three Ladies, c.*1716/17.
Red, black and white chalk,
268 × 327 mm (10⁹⁄₁₆ × 12⅞ in).
JPGM, 86.GB.596.

WHITE CHALK
Giovanni Battista Piazzetta
(1683–1754): *A Boy Holding a Pear,*
*c.*1740. Black and white chalk on
blue-grey paper, 392 × 309 mm
(15⁷⁄₁₆ × 12³⁄₁₆ in). JPGM, 86.GB.677.

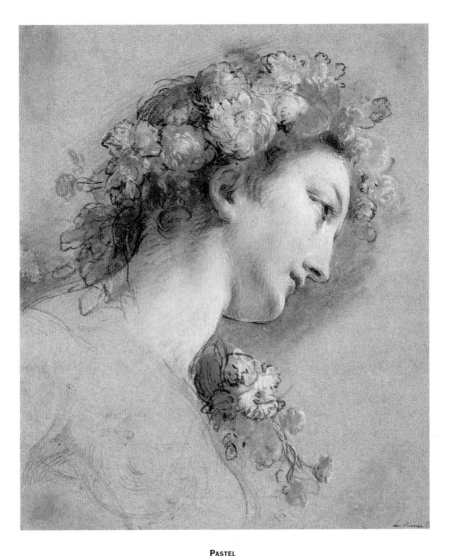

PASTEL
François Lemoine (1688–1737): *Head of the Goddess Hebe*.
Pastels on blue paper, 311 × 258 mm (12¼ × 10⅛ in). BM, 1850–3–9–1.

Pastels originated in Northern Italy in the sixteenth century and were used by many artists, notably Bassano and Barocci. At the same time portraits in pastel were being made by Hans Holbein the Younger and Jean Clouet. The technique was perfected in the eighteenth century, especially by artists such as Quentin de La Tour and Rosalba Carriera, again chiefly for portraiture, and the art was revived in the late nineteenth century by Degas and Toulouse-Lautrec among others. See CRAYON and CONTÉ CRAYON.

CHARCOAL

Jean-Baptiste Siméon Chardin (1699–1779): *Study for a Seated Man (recto)*, *c.*1720–25.
Charcoal and white chalk, 256 × 167 mm (10¹⁄₁₆ × 6⁹⁄₁₆ in). JPGM, 85.GB.224.

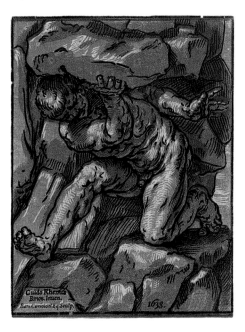

CHIAROSCURO WOODCUT
Bartolommeo Coriolano
(*c*.1599–*c*.1676)
after Guido Reni
(1575–1642): *A Giant*.
Chiaroscuro woodcut,
257 × 193 mm
(10⅛ × 7⅝ in).
BM, W.5–30.

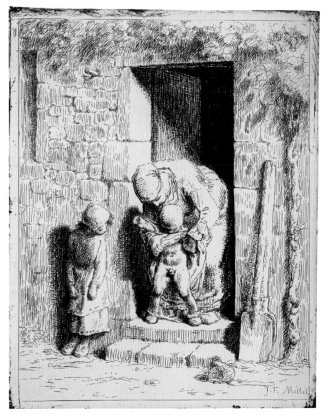

CLICHÉ VERRE
Jean-François Millet
(1814–75): *La
Précaution Maternelle*.
Cliché verre, 288 × 225
mm (11⅜ × 8⅞ in).
BM, 161*C.21,
1922–4–10–245.

CHARCOAL

Charcoal is made by reducing wood to carbon in heated chambers from which oxygen is excluded in order to prevent combustion taking place. Like chalk, it was cut into pieces and used in holders. It was used frequently as a preparatory medium in drawings intended for completion in other media, but sometimes it was used alone, especially by German artists of the sixteenth century, notably Dürer and Hans Burgkmair. Charcoal drawings are often protected from smudging by the application of a FIXATIVE sprayed onto the drawing.

From about the middle of the sixteenth century a new medium, 'oiled charcoal', was employed to increase the permanence of charcoal drawings. Natural charcoal sticks were soaked in linseed oil, wiped and then used for drawing before the oil hardened by oxidisation. This type of charcoal produced a rich black line that did not smudge and in time hardened like oil paint.

CHIAROSCURO WOODCUT

A colour WOODCUT used to suggest the effect of a monochrome tonal drawing. A different block was normally used for each shade of colour. The process was particularly popular in Italy and Germany in the sixteenth century.

CLICHÉ VERRE

A technique used by several French etchers in the nineteenth century, notably Corot and Daubigny. The surface of a glass plate was covered with an opaque ground, and the artist would draw onto this ground with a point, leaving the glass transparent where the lines were to print black. The glass plate was then used as an ordinary photographic negative, and a print produced by exposing light through it onto sensitised photographic paper. *(See Cliché-verre: Hand-Drawn, Light-Printed – A Survey of the Medium from 1839 to the Present,* exhibition catalogue, Detroit Institute of Arts, 1980.)

COLLAGE

This French word may be translated as 'sticking', 'gluing' or 'pasting'. (Another French term is *'papier découpé'*.) The term 'collage' in effect means any work composed of pieces of paper or other materials which have been painted, drawn or printed and are stuck onto a supporting surface.

In the eighteenth century the flower artist Mrs Mary Delany (1700–88) invented a medium known as 'paper mosaic' or 'plant collage'. Her method was to cut the petals and leaves from coloured paper, and paste them on a background of black paper. Some unusual tints were created from paper on

COLLAGE
Mary Delany (1700–1788): *Stewartia Malacodendron*. Paper mosaic or collage,
331 × 226 mm (13 × 8⅞ in). BM, 1897-5-5-843.

which the colours had run, and occasionally she added touches of watercolour
and even real leaves. During the twentieth century both the use of collage for
pictorial effect and the materials involved in it have substantially increased in
range. Kurt Schwitters, for example, employed printed ephemera, fabrics and
a whole variety of small objects as elements in his collages.

COLLECTORS' MARKS

These small marks, usually composed of an initial or initials but sometimes a device, are stamped or applied by some other means at the corner or some other unobtrusive area of drawings or prints to indicate ownership. Originally they were often applied posthumously by executors. They are usually written or stamped in ink, but are sometimes embossed into the paper without inking (blind stamps). Such marks do not denote authenticity, but a work with a provenance from one or several important collections can often be of high quality. The standard work on the subject is *Les Marques de Collections de Dessins et d'Estampes* by Frits Lugt, Amsterdam, 1921; a supplement to this work was published in 1956.

A 'studio stamp' was applied to drawings left in an artist's studio after his or her death. Such stamps are a useful but not infallible guide to authenticity. Degas had a large collection of drawings by other artists and after his death these were stamped with the Degas studio stamp, as were his own drawings. Such stamps were often applied in France in the nineteenth century, frequently prior to the sale or dispersal of drawings.

COLOUR PRINTING

There is a fundamental distinction between 'colour prints' and 'coloured prints'. A colour print is one printed with inks of different colours; a coloured print is printed in ink of one colour and has had extra colouring added by hand.

INTAGLIO plates printed in colours may either be printed from one plate inked in different colours or from several plates each inked in a separate colour. Colour WOODCUTS, LITHOGRAPHS and SCREENPRINTS are normally produced using different stones or screens for each colour.

CONTÉ CRAYON

Invented in 1795 by Nicolas Jacques Conté (1755-1805), this was a mixture
of refined GRAPHITE (see also PENCIL) and clay. During the Napoleonic Wars
graphite for pencils was in short supply and Conté's invention both used less
graphite and improved the quality of pencils for drawing by producing varying
degrees of hardness. In this way he helped to increase the popularity of pencils
as drawing instruments.

In the nineteenth century Georges Seurat made some remarkable studies for
his major painting *La Grande Jatte* in Conté crayon, using the medium to
achieve outstandingly soft effects of texture (see p. 24).

What are currently marketed as 'Conté crayons' are different in
composition, being a particular variety of fabricated CHALK.

COPIES, REPRODUCTIONS AND FAKES

The question of whether a work on paper is a copy or an original is a problem
which is likely to confront the amateur and the specialist alike, and it is often a
difficult one to resolve. Copying of drawings and watercolours for the purposes
of record or study is a long-established and entirely legitimate activity. For
example, Rembrandt encouraged pupils to copy his drawings and would regularly

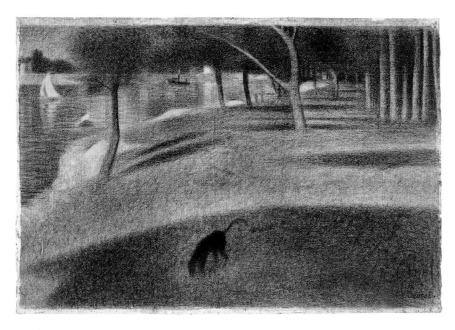

add corrections to their efforts. Claude Lorrain made a drawn inventory of his own oil paintings called the *Liber Veritatis* (British Museum, formerly at Chatsworth House) as a form of reference. Not only are these works of great beauty in themselves but their significance is frequently increased because they provide a record of the composition of paintings which are now lost.

Copies made with the dubious purpose of being passed off as original works by great artists appeared as early as the sixteenth century, when numerous drawings purporting to be by Michelangelo were circulated during his own lifetime. This practice has continued to the present day and fakes have been discovered of most major draughtsmen as well as of others not of the first rank. In more recent years two well-known fakers warrant a mention: Tom Keating (1917-84) made a number of watercolours which were deceptive pastiches of works by Samuel Palmer, while Eric Hebborn (1934-95) produced exceptionally convincing drawings in the style of many of the old masters. Such practitioners invariably employ old papers, traditional inks and innumerable other tricks, and their activities defeat experts on occasion.

The only rule that can be offered is to err on the side of caution: a work which appears too good to be a true or a ludicrous bargain should be examined with care and a healthy suspicion.

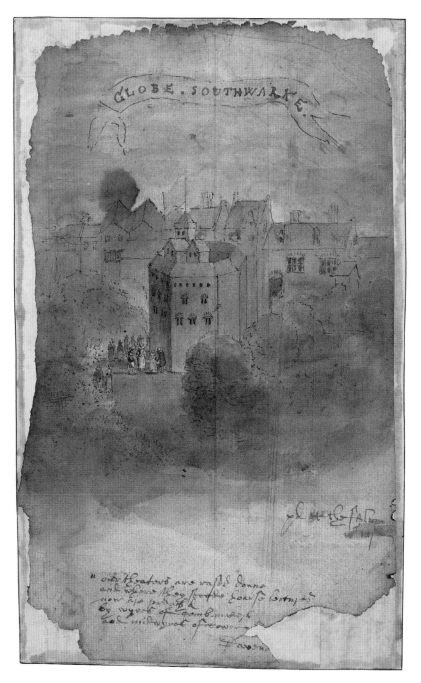

FAKE

Anonymous 18th-century but purporting to be contemporary with Shakespeare: *The Globe Theatre*. Pen and black ink with watercolour on a 'fragment' of paper, approx. 297 × 179 mm (11 11/16 × 7 1/16 in), inscribed 'Globe Southwarke'. Based on a section of C.J. Visscher's panoramic view of London published in 1616. BM, Crowle Pennant 11, 94.

Print techniques which give the effect of drawings or watercolours include AQUATINT, CRAYON MANNER and SOFT-GROUND ETCHING. These are not intended to deceive but they can catch out the unwary. For example, a delicately hand-coloured aquatint framed with the lettering obscured or removed looks much like a watercolour, but the aquatint grain should be discernible with the help of a magnifying glass. Prints which reproduce paintings or drawings can, in the hands of a master, be remarkable works of art in their own right and should not be despised. Their intention was frequently to make the work of artists available to people unable to afford oil paintings or drawings. Among the greatest of the reproductive printmakers were Francesco Bartolozzi (1727-1815, see STIPPLE ENGRAVING), Louis Marin Bonnet (1736-93, see CRAYON MANNER), and Valentine Green (1739-1813, see MEZZOTINT).

In the nineteenth century certain museums in Germany and elsewhere issued photogravure reproductions of master prints in their collections (see PHOTOMECHANICAL PROCESSES). Intended for educational use, they were usually sold as sets or groups of sheets, stamped as reproductions on the VERSO, in albums. These high-quality items, once removed from their identifying folders and framed, can prove deceptive, since they are precisely accurate and were derived from fine original impressions.

COUNTERPROOF

An impression made by running a print, before the ink has dried, through a press against another sheet. The resulting image is in reverse to the print but in the same direction as the engraving on the plate, and often helps the artist in making corrections. Counterproofs can be recognised because the image is flatter and weaker than an impression taken directly from the plate. The term is sometimes also applied to OFFSETS of drawings.

CRAYON

(French *craie* = chalk.) Modern crayons made in the form of sticks are composed of colours combined with oily, waxy or greasy binding media, or with combinations of water-soluble and fatty binders.

In the seventeenth and eighteenth centuries the word was used to describe both CHALK and PASTEL drawings and seems generally to have implied the employment of colour. By the late eighteenth and early nineteenth centuries the modern form of wood-encased crayon (with its essential greasy nature) began to be developed, and various recipes for the manufacture of crayons were proposed, most notably by Alois Senefelder, who needed to use them in his

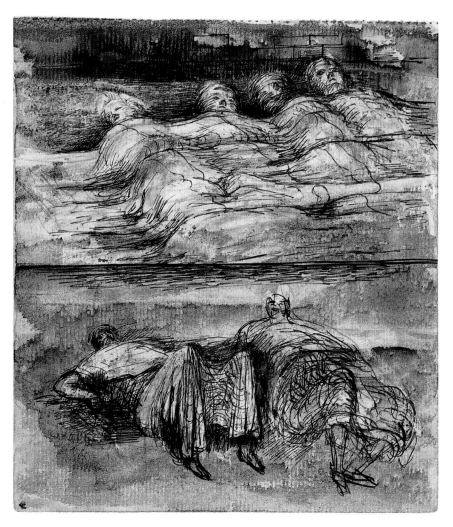

new invention of LITHOGRAPHY. He mentioned combinations of wax, tallow,
spermaceti (the white wax from the sperm whale), soap and shellac. In the
twentieth century crayons have been used to great effect by artists such as
Picasso and Henry Moore.

CRAYON MANNER

A technique invented in 1757 by a French engraver, J. C. François (1717–69),
in order to imitate the chalk drawings of artists such as Boucher. He developed

new varieties of ROULETTES and 'mattoirs' (tools with rounded spiked heads)
which he used not directly onto the plate, but onto an etching ground in order
to soften the effect. By printing on a suitable paper in a red or brown ink he
produced deceptively accurate facsimiles of drawings.

DIGITAL PRINT
Richard Hamilton (b. 1922): *The Annunciation*, 2005. Colour Epson inkjet
digital print, 439 × 439 mm (17¼ × 17¼ in). BM, 2005–12–30–10.

DIGITAL PRINTMAKING

Computer-generated printmaking has become increasingly popular with
contemporary artists. They work with many varieties of software (one such is
PhotoShop) to create, collage and manipulate images on the screen. Recent
improvements in ink, paper and colour-fastness have largely overcome the
initial 'hard-copy problem' of digital printmaking. By whatever method the
image is generated, the human element remains paramount. *Giclée* prints
(from the French *gicler*, to spray) are digitally generated images printed in high
quality and non-fugitive colours which are regularly published in very large
EDITIONS.

The digital world is ever changing and today's technology for making digital
prints is just as likely to be superseded by another tomorrow. Richard
Hamilton, a leading pioneer of digital printmaking, has stated, '…the electronic
paintbox…doesn't replace the old media but it can encourage new ways of
thinking and working' ('The hard copy problem', in *Richard Hamilton, Subject
to an impression*, exhibition catalogue, Kunsthalle Bremen, 1998, pp. 6–7).

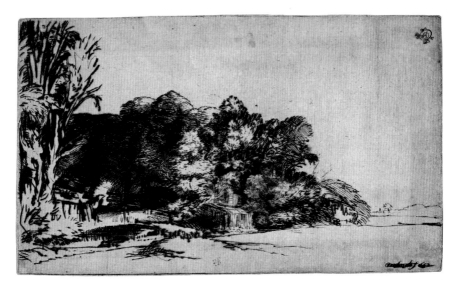

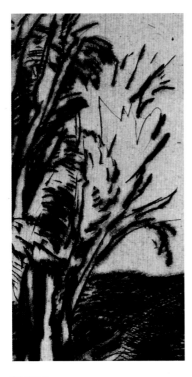

DRYPOINT

A member of the class of INTAGLIO prints. The line is scratched directly into the plate with a metal point, which is pulled across the surface and not pushed as in engraving. The metal displaced from the scratched line is thrown up on either side, and this residue of metal fragments is called the 'burr'. This gives the line a rich velvety texture when inked, but the burr is fragile and quickly wears down with each impression. There is thus a noticeable difference in quality between early and late impressions from a drypoint plate. Drypoint is often used in combination with other techniques, especially ETCHING. The earliest pure drypoints were made by the Master of the Housebook, who worked in about 1480 in the region of the middle Rhine, but the greatest exponent of the technique was Rembrandt.

A drypoint can be difficult to distinguish from an etching once the burr has been worn down, but sometimes the character of the line will give the answer: for example, a rounded end will betray etched lines, and a very closely worked area of shading, drypoint.

ÉCORCHÉ

(A French term, meaning 'skinned'.) From the Renaissance onwards artists frequently drew studies from clay or plaster figurines representing the human body with the skin removed to show the muscles. The term '*écorché*' is applied both to the figurine and to the drawing made from it.

EDITION

The practice of limiting the number of IMPRESSIONS of a print in order

Parmigianino (1503–40): *An Écorché Right Arm.*
Pen and brown wash over red chalk,
128 × 77 mm (5 × 3 in). BM, 1905–11–10–15.

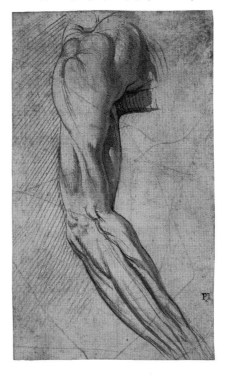

to create an artificial rarity for the benefit of the collector is a relatively recent development, dating only from the last quarter of the nineteenth century. Often the impressions are signed and numbered by the artist; a number such as 6/20 indicates that the impression was the sixth in an edition of twenty impressions. When the edition is complete the plate or block is often defaced by scratching lines across it; this is known as 'cancelling'. In the early days of printmaking editions were not limited: so long as demand continued the plate was used until it wore out.

ENGRAVING

A term sometimes used of all INTAGLIO prints but properly confined to those made with a tool called a 'graver' or 'burin', which is a small metal rod with a sharpened point. It is pushed across the plate, forcing the metal up into slivers in front of the V-shaped line. These pieces of metal are removed from the plate with a sharp bladed instrument (the 'scraper').

An engraving can usually be distinguished from an ETCHING by the ends of

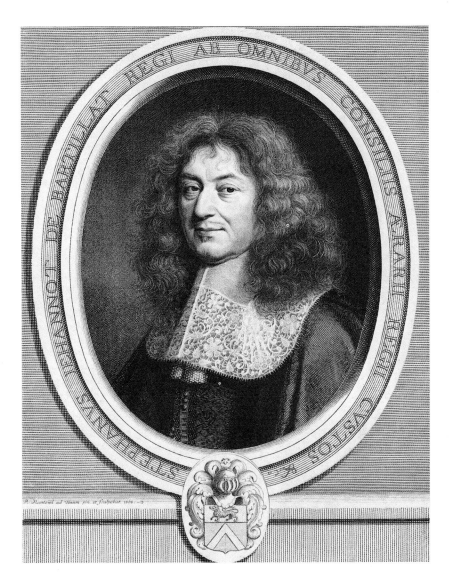

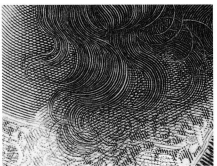

ENGRAVING
Robert Nanteuil (1630–78):
Etienne Jehannot de Bartillat, 1666.
Engraving, 326 × 256 mm (12⅞ × 10¹⁄₁₆
in). BM, 1927–10–8–92.

ENGRAVING
Enlarged detail.

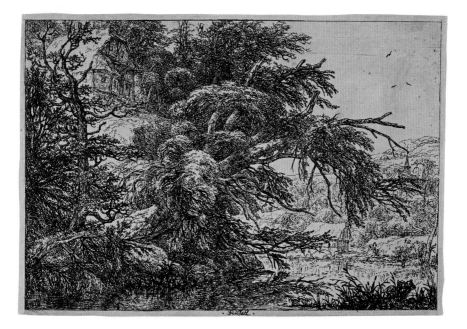

ETCHING
Jacob van Ruisdael (1628/9–82):
The Cottage on the Hill. Etching,
194 × 279 mm (7⅝ × 11 in).
BM, Sheepshanks 1113.

ETCHING
Enlarged detail.

the lines: these taper into a point in engraving, but in an etching the ends are blunt and rounded. An engraved line, being cut, is sharp and clean, whereas an etched line, being drawn and bitten unevenly by the acid, is slightly irregular.

ETCHING

A variety of INTAGLIO printmaking in which the lines in a metal plate are bitten (etched = eaten) by acid. The polished surface of the plate is first covered with a thin layer of ground, composed of waxes, gums and resins. The melted ground is usually laid on with a 'roller' or 'dabber'. The etcher draws through

the ground with a metal point (the 'etching needle'), which exposes the metal. The plate is then immersed in a bath of acid, which bites into the plate through the exposed lines. The depth of the line, and thus its darkness when printed, is determined by the length of time the plate remains in the bath and the strength of the acid solution. The etching ground offers almost no resistance to the needle, so the artist has much the same freedom as in drawing.

Etching was invented as a method of decorating armour, and was already known in the fourteenth century. The earliest dated print from an etched plate, of 1513, is by Urs Graf, and few, if any, are likely to have preceded it.

The chief methods of distinguishing an etching have been described under ENGRAVING.

FIXATIVES

A fixative is frequently used to protect a dry drawing medium once it has been applied to a surface. However, all fixatives may have an effect on the drawing media and paper, causing colour change or darkening. They can also appear to affect the spontaneity of the work by softening or flattening the strokes.

It is likely that the fixatives used in the sixteenth century and later were composed of adhesive binders obtained from natural sources such as diluted skimmed milk, diluted white of egg, fig juice, rice water, gums and shellac among others. Today most fixatives are produced from synthetic resins in solvents. Modern fixatives are usually applied in the form of a spray, but before this they were often spread quickly over the drawing with a thick brush.

Pastels were often laid face down on a bath of thin glue size or gum-water in an attempt to avoid long-term damage to the fragile colours.

FRESCO

A highly skilled method of wall or ceiling painting, of ancient origin, perfected during the Renaissance in Italy. The paint used was of the distemper/TEMPERA type, in which the colours are mixed with some binding substance soluble in water, and was usually applied to the wet plaster. As the plaster dried, the pigment became sealed within it. Paint could also be applied to the plaster when dry – *a secco* – an altogether easier procedure but one which had the serious disadvantage of being less durable. Sometimes the *a fresco* and *a secco* techniques were applied in combination. See also SINOPIA.

In the second quarter of the nineteenth century the interest in fresco painting revived, especially in England and Germany. Some of these so-called frescoes were in fact executed in oil-based paint, unlike their Renaissance predecessors.

GLASS PRINTS

From the late seventeenth to the early nineteenth centuries MEZZOTINTS, usually of popular genre or mythological subjects, were frequently glued face down onto glass and abraded from behind to remove all the paper. The film of ink left behind was then hand-coloured and the glass framed.

GOUACHE

The term was first used in France in the eighteenth century to describe a method of painting with colours made opaque by mixing them with chalks or whites in a medium of gum and honey, and only adopted into English in 1882. Its use was extended to refer also to a drawing made in this medium. Today the term is also used loosely to describe any drawing made entirely in BODYCOLOUR. See also TEMPERA.

GRAPHITE

The essential ingredient of PENCILS, graphite is a crystalline allotropic form of carbon. It is also called 'black lead' and 'plumbago'. One of the earliest discoveries of it was in England in about 1550 in Borrowdale (Cumbria), where a mine was subsequently opened.

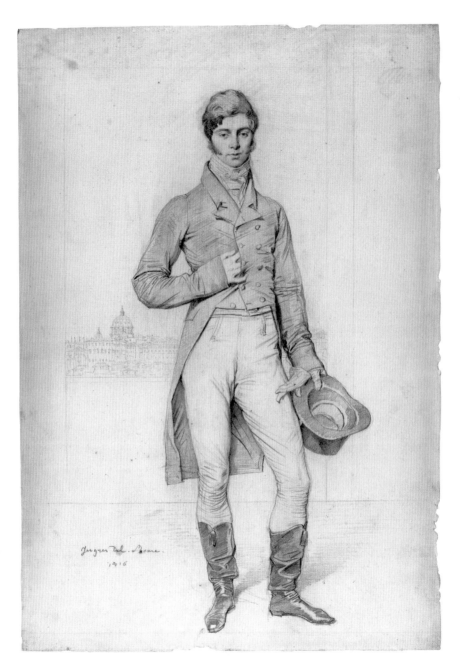

GRAPHITE
Jean-Auguste-Dominique Ingres (1780–1867): *Portrait of Lord Grantham*, 1816.
Graphite, 405 × 282 mm (15¹⁵⁄₁₆ × 11⅛ in). JPGM, 82.GD.106.

GRISAILLE

A French term adopted into English and derived from *gris*, meaning grey. The term covers works executed in grey or other monotones in BODYCOLOUR, WASHES or oils, sometimes to give an impression of low relief. The technique was employed by Mantegna and was later used particularly by sculptors for preparatory studies. The Italian term, which is mentioned by Vasari, is *chiaroscuro*.

GUM ARABIC

The natural secretion of the acacia tree and a substance still used in the manufacture of WATERCOLOURS. Its chief value lies in its ability to assist the paint to adhere to the paper, but it also maintains a stable dispersal of pigment particles in water until the film of wash has dried and the colours are gummed in place, so making a significant contribution to the final appearance of the work.

In the Victorian period gum arabic was also used on its own, applied on top of areas of watercolour. When dry, the gum became a transparent film, causing a deepening of tone and a richer effect. Its presence can often be recognised because it frequently cracks.

HEIGHTENING

A term used for the addition of highlights by the application of white BODYCOLOUR or WHITE CHALK. A similar effect can be gained by SCRAPING through the medium to reveal the white of the PAPER.

IMPRESSION

The term applied to any print from a block, plate or stone. In the sense in which we talk of a 'copy' of a book, the word 'impression' should be used of a print to avoid confusion with 'copy' in the sense of a facsimile.

INKS

1 Drawing inks

Iron-gall ink. Most Renaissance PEN drawings were made using iron-gall ink, which was the traditional medium for writing. It was obtained from a suspension of iron salts in gallic acid taken from the nut-galls (oak apples) of oak trees, excrescences caused by disease. Although almost black when first applied, this ink turns brown with time, hence the characteristic appearance of many 'Old Master' drawings. It is also acidic in nature, which can cause fracturing or holes in PAPER.

IRON-GALL INK
Guercino (Giovanni Francesco Barbieri, 1591–1666):
Christ Preaching in the Temple, c.1625–30. Pen and brown ink and brown
wash, 269 × 427 mm (10⁹⁄₁₆ × 16⁹⁄₁₆ in). JPGM, 84.GG.23.

Carbon ink. It is known that black carbon ink was used by the ancient
Chinese and Egyptians, but it was not widely used for drawing in Europe until
the sixteenth century. Carbon particles were obtained from the soot of burning
oils, resins or resinous woods or the charcoal of many kinds of woods. These
black particles were ground to a powder and combined with a binding
medium. This kind of ink does not turn brown or fade.

Indian or Chinese ink. Essentially lampblack (carbon ink) mixed with gum
and resin and hardened by baking. It is waterproof and the resin gives the line
a sheen.

Bistre. A brown ink made by extracting soluble tars from wood soot. Water
was used to dissolve the dark brown greasy soot, the solution was filtered to
remove the insoluble sediment, and the ink colour was intensified by boiling or
evaporating part of the water in the solution. Bistre was a popular drawing ink
in the seventeenth and eighteenth centuries.

Sepia. A pigment ranging from black to yellow-brown, extracted from the
ink-bag of the cuttle-fish. This did not become popular as a drawing medium
until the end of the eighteenth century, when a suitable chemical extraction
method was found to produce a concentrated ink from the natural sepia.

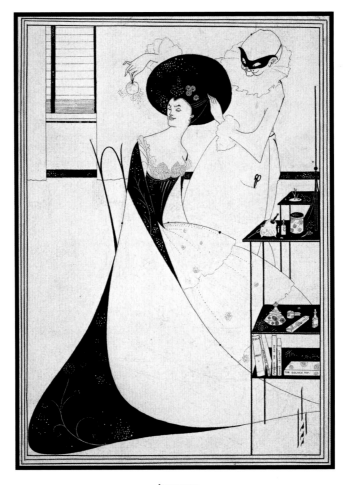

Aubrey Beardsley (1872–1898): *The Toilet of Salome*, *c*.1894. Pen and brush
and Indian ink, 227 × 162 mm (8¹⁵⁄₁₆ × 6⅜ in). BM, 1919–4–12–1.

2 Printing inks

Printing ink is an oil-based fluid distinct from the water-based liquid used for
writing. It was apparently invented, or at least developed, by Gutenberg, and
was as essential to his success as his invention of the printing press and
movable type. The ink is made by grinding lamp-black very fine and mixing it
with oil; less oil is used in a RELIEF or typographic ink than in INTAGLIO ink in
order to make it more viscous so that it will not run into the hollows.
Lithographic ink has to contain grease to resist water, this being the
fundamental principle of LITHOGRAPHY. In SCREENPRINTING the ink can be
almost anything that will pass through the mesh and adhere to paper.

INSCRIPTION

Any handwriting on a print or drawing which is not a SIGNATURE; if an artist's name is said to be 'inscribed', the inference is that it has been added by someone else. An inscription may be a note by the artist, or by a later owner; or it may have been on the sheet before the artist used it.

INTAGLIO PRINTING

The method of printing used for metal plates worked as ENGRAVINGS, DRYPOINTS, ETCHINGS, MEZZOTINTS, STIPPLES AND AQUATINTS. The paper receives the ink from the incised lines and not from the surface of the plate. The ink is pressed into the lines with a pad called a 'dabber'. Any left on the surface is removed by wiping muslin across the plate, and the process is usually completed with the palm of the hand. The paper is dampened and passed through a PRESS on a board that slides between one or two rollers. The pressure must be strong enough to force the damp paper into the lines and lift the ink out onto the paper. Considerable varieties of effect can be obtained by wiping so as to leave a film of ink on the surface of the plate (SURFACE TONE). See also RETROUSSAGE.

An intaglio print can normally be recognised by the PLATE-MARK and by the fact that the ink stands up from the paper in very slight relief, which can often be detected by touch.

LEAD POINT

A type of METALPOINT in which lead or an alloy of lead and tin was used. It was commonly employed in the fifteenth and sixteenth centuries as an underdrawing for a work intended to be completed in pen and ink, black chalk or some other medium. The lead point was hard and indented the surface of the paper, but the mark it made was very faint. Occasionally, lead point was used for the whole drawing. Unlike metalpoint, lead point was generally used on papers on which no ground had been laid. It was a conveniently portable implement before the invention of the graphite PENCIL.

LEAD POINT

Jacopo Bellini (*c*.1400–1470/1): *A Tournament*. Lead point on (prepared?) paper. 415 × 336 mm (16⅜ × 13¼ in). BM, 1855-8-11-54.

LETTERING

A term used to refer to letters engraved on a print. Information about the artist (designer) and engraver is usually given below the bottom left and right-hand corners respectively. The most commonly found terms are listed below. They are mainly Latin in origin.

Composuit, 'Designed', 'designer'

Cum privilegio, Implying the exclusive right to publish, corresponding to modern copyright, granted by some political or ecclesiastical authority

Delineavit (delin.), delineator, 'Drew', 'draughtsman'

Excudit (excud., ex.), 'Published'

Fecit (Fec., f.), 'Etched' or 'engraved'

Incidit (incid., inc.), incisor, 'Engraved', 'engraver'

Invenit (inv.), inventor, 'Designed', 'designer'

Lith, 'Drew' or 'printed on stone'. This is ambiguous; it can be used by both the lithographic draughtsman and the lithographic printer.

Pinxit (pinx.), pictor, 'Painted', 'painter'

Published according to Act of Parliament. This established copyright in accordance with an act of the British Parliament. The first artistic copyright act was passed in 1735, chiefly due to the efforts of Hogarth.

Sculpsit (sculp., sc.), sculptor, 'Engraved', 'engraver'.

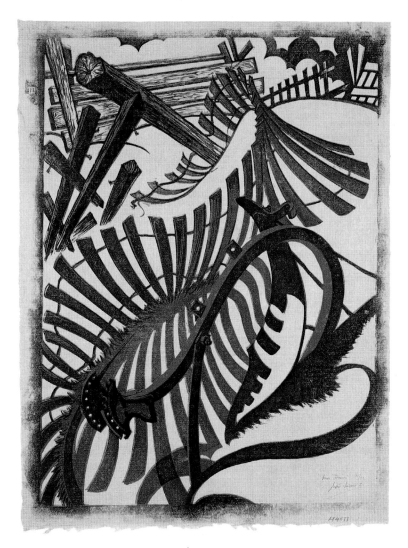

LINO-CUT

Sybil Andrews (1898–1992): *Anno Domini, c.*1930.
Lino-cut, 430 × 325 mm (16¹⁵⁄₁₆ × 12¹³⁄₁₆ in). BM, 1980–1–26–105.

LINO-CUT

(Linoleum cut) The process is the same as WOODCUT, except that the surface
employed is linoleum and not wood. Lino-cutting was introduced on the
Continent at the beginning of the twentieth century and became especially
popular in the late 1920s in Britain in the hands of artists such as Claude Flight
(1881–1955). (See Claude Flight, *The Art and Craft of Lino Cutting and
Printing,* London, 1934.)

LITHOGRAPHY

The basis of lithography is the fact that grease and water repel each other. Anything drawn on a suitable surface in some greasy medium can be printed in the following way: the surface is first dampened with water, which only settles on the unmarked areas since it is repelled by the greasy drawing medium. The surface is then rolled over with greasy printing ink, which will only adhere to the drawn marks, the water repelling it from the rest of the surface. Finally, the ink is transferred to a sheet of paper by running the paper and the printing surface together through a 'scraper press' (see PRESSES).

Lithography was invented in 1798 in Munich by Alois Senefelder. It was the first entirely new printing process since the invention of INTAGLIO in the fifteenth century. Stone was the first surface used for printing (hence lithography = 'stone-drawing'), and the most suitable kind was found to be limestone from the Solenhofen region in Bavaria. The most frequently used alternative surface is zinc and occasionally aluminium.

Lithographs can present a wide variety of appearance because any kind of drawing instrument can be used so long as the drawing medium itself is greasy. A 'pen lithograph' requires a smooth surface on the stone but in a 'chalk lithograph' the surface is given a grainy texture by abrasion. A third variety is the 'wash lithograph' (sometimes called a '*tusche*' lithograph from the German term for ink).

A lithograph has no PLATE-MARK as in an intaglio print, but the area which has been flattened in the press, corresponding to the area of the surface of the stone, can sometimes be distinguished.

MACULATURE

A faint second impression from an INTAGLIO plate, taken without re-inking in order to clean the ink completely out of the lines.

MARGIN

Any area outside the PLATE-MARK of an INTAGLIO print, or outside the printed border of other types of print. Before the eighteenth century single-sheet prints were almost invariably trimmed to their borders or plate-marks by collectors. A print trimmed just outside the plate-mark is often referred to as having 'thread margins'.

MEASUREMENTS

Prints and drawings are usually measured in centimetres or millimetres, height preceding width. Normally the entire sheet is measured, but occasionally the term 'sight size' may be encountered. This means that the person measuring the drawing was unable to see the full extent of the sheet (perhaps because of a mount or frame) and so only what could be seen was measured.

INTAGLIO prints are measured to the PLATE-MARK, but if this has been trimmed away the sheet is measured instead. WOODCUTS, LITHOGRAPHS and SCREENPRINTS are measured to the widest point of the image.

METALCUT

At certain periods, metal plates have been cut with the intention of printing

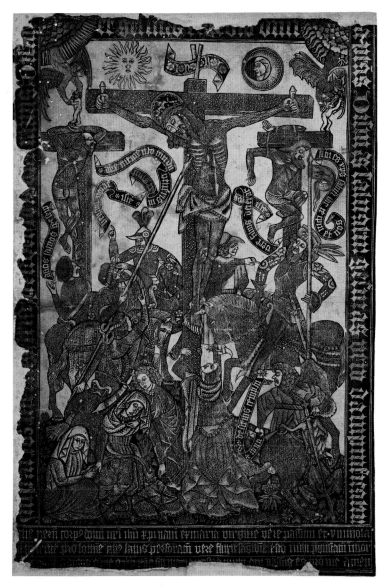

METALCUT

Anonymous German: *The Crucifixion*, *c*.1450–60. Metalcut in the dotted manner with hand colouring, 403 × 268 mm (15⅞ × 10⁹⁄₁₆ in). BM, 1845–8–9–205.

them in relief. In the fifteenth century, prints in the 'dotted manner' or '*manière criblée*' were produced in France and Germany. The plate was engraved with the outline of the subject and the large areas that would have otherwise printed unrelieved black were decorated by using punches and stamps. In the

METALPOINT
Raphael (Raffaello
Santi, 1483–1520):
*St Paul Rending his
Garments.* Metalpoint
and white bodycolour
heightening on lilac-
grey prepared paper,
230 × 103 mm
(9¹⁄₁₆ × 4¹⁄₁₆ in). JPGM,
84.GG.919.

eighteenth century William Blake used a different variety of relief printing with metal in his illuminated books; in these the background was etched away, leaving the lines of the text and the image in relief.

METALPOINT

This technique was in frequent use in the fifteenth and early sixteenth centuries in Italy, almost exclusively in Florence and Umbria. An instrument with a point of gold, silver or other metal was used for drawing on a prepared paper. A ground composed of powdered bones or lead white mixed with gum-water or size was applied to the paper in several coats. This ground would have been naturally off-white in appearance but coloured pigments were often mixed in. The metal point reacted chemically with the ground on the paper, thus producing a line. Highlights were brushed in with white BODYCOLOUR. See also HEIGHTENING.

During the Renaissance the medium was used for finished drawings of a type that could not be achieved with the quill PEN or with CHALK. Metalpoint was superseded after the sixteenth century by the graphite PENCIL, which could be corrected more easily, but it was briefly revived in the later nineteenth century by artists such as Alphonse Legros (1837–1911).

MEZZOTINT

A member of the class of INTAGLIO prints, and essentially a tone process in which a metal plate is roughened or ground all over using a tool with a curved and serrated edge (the 'rocker'), producing an overall 'burr' which prints a deep velvety black. The artist scrapes down the burr in proportion to the lightness of tone that he requires. The main distinguishing feature of the process is that the artist works from dark to light – from a black ground to the highlights, not from a white ground to the black lines or shadows. As in DRYPOINT, the richness of a mezzotint depends largely on the burr, so relatively few very fine IMPRESSIONS can be taken before deterioration of the surface begins. Ludwig von Siegen, a German, took the first step towards the mezzotint technique (he mentions his discovery in a letter of 1642) by using a ROULETTE to build up a design on the plate; but true mezzotint requires a rocking tool, the inventor of which is thought to have been Prince Rupert, who 'scraped' some plates during his retirement in Frankfurt after the English Civil War.

The technique was particularly popular in England (it is sometimes referred to as 'la manière anglaise'), where it was extensively used in the eighteenth century, above all for the reproduction of portraits. In the early nineteenth century steel plates were used, which, being harder than copper, permitted

MEZZOTINT
Abraham Blooteling (1640–90) after Paulus Moreelse
(1571–1638): *St Peter*. Mezzotint, 354 × 278 mm
(13¹⁵⁄₁₆ × 10¹⁵⁄₁₆ in). BM, 1838–4–20–89.

MEZZOTINT
Enlarged detail.

many more impressions to be printed. A mezzotint is easy to recognise because of the distinctive manner in which the design emerges from the black background.

MODEL BOOKS

Books of drawings which were intended as patterns or models and used as source material by artists, apprentices and craftsmen. The earliest model books are from ancient Egypt; in Europe they are known from medieval times. Model books transmitted designs from artist to artist and craftsman to craftsman and served as reservoirs of ideas for every branch of the fine and applied arts. From the fifteenth century this role was also filled by printed pattern books. (See R. W. Scheller, *A Survey of Medieval Model Books*, Haarlem, 1963.)

MODELLO

A finished study, on a reduced scale, made in preparation for a larger work. Such studies are often SQUARED for enlargement. Some contracts stated that a modello had to be made, sometimes with a proviso that there should be no subsequent changes in the final work.

MODELLO
Andrea Mantegna
(1431–1506): *Study of Four Saints (Peter, Paul, John the Evangelist and Zeno)*, 1456–9. Pen and brown ink with traces of red chalk, 195 × 131 mm (7¹¹⁄₁₆ × 5³⁄₁₆ in). JPGM, 84.GG.91.

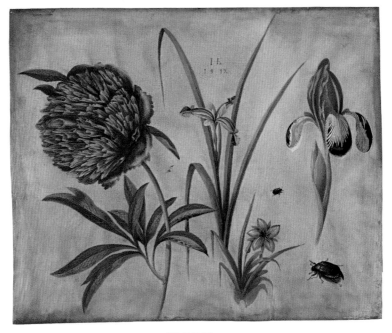

MONOGRAM

Hans Hoffmann (*c*.1530–1591/2): *Flowers and Beetles*, 1582. Tempera and white chalk over black chalk on vellum, 321 × 387 mm (12⅝ × 15¼ in). JPGM, 87.GG.98.

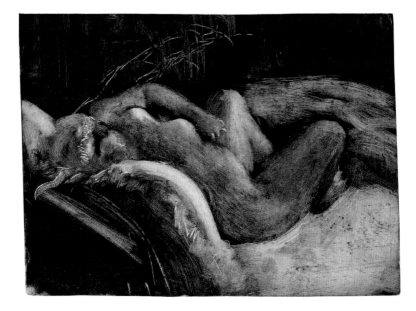

MONOTYPE

Edgar Degas (1834–1917): *Le Sommeil*, *c*.1883–5. Monotype, 276 × 378 mm (10⅞ × 14⅞ in). BM, 1949-4-11-2425.

MONOGRAM

A character usually composed of the initial letters of a name, frequently interwoven. Monograms are often found in the place of SIGNATURES on drawings and prints.

MONOTYPE

The artist draws his design in printing ink on a plate or sheet of glass, and transfers it to a sheet of paper by running it through a press while the ink is still wet. The process was invented by Giovanni Benedetto Castiglione in the 1640s. It was revived in the nineteenth century, notably by Degas, and continues to appeal to artists for the remarkable effects that can be obtained. Only one strong IMPRESSION can be made by this process, hence its name, but sometimes a second, weaker impression is also printed. Another variety of monotype is thought to have been invented by Paul Gauguin. This involves drawing with a hard pencil on the back of a sheet of paper laid face down onto a surface covered with tacky ink. The design is thus picked up on the other side in lines with a distinctive blurred character.

OFFSET

Offsets of drawings, usually of red chalk (for prints see COUNTERPROOF) were made by damping and pressing a drawing onto another piece of dampened paper. The impression obtained appeared in reverse and offsets were almost invariably fainter in tone than the original drawing, which might also lose some of its original crispness in the process. This was one of the methods used by engravers to reverse a design in the direction in which it had to be engraved on the copper plate.

Offsets were also made (especially in eighteenth-century France) to increase the number of originals available for sale to collectors. Offsetting saved the artist the trouble and hard work of making an

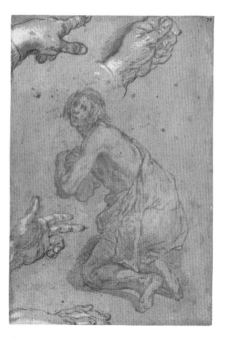

OFFSET

Abraham Bloemart (1564–1651): *Four Studies of Hands and an Offset of a Kneeling Young Man* (*verso*), *c.*1620–30. Red chalk heightened with white, 251 × 171 mm (9⅞ × 6¾ in). JPGM, 83.GB.375.

identical copied version of a particularly popular drawing. Such offsets could be reworked by the artist.

OFFSET LITHOGRAPHY

The design is prepared on the stone, or more usually a metal plate, in the normal way (see LITHOGRAPHY). The inked image is then printed onto a cylinder covered with a rubber blanket, from which it is transferred onto the paper. Hence the image appears, when printed, in the same direction as it was drawn. Offset lithography is now the normal method of printing all sorts of material (not just artistic), as the plate can be wrapped round a cylinder and enormous printing speeds obtained by using rollers.

OLEOGRAPH

A nineteenth-century process in which an ordinary colour LITHOGRAPH was varnished and/or impressed with a canvas grain in order to make it look more like an oil painting.

PAPER

Paper is the most common support for drawings, prints and watercolours. According to tradition, paper was invented in China at the beginning of the second century AD, but it was not manufactured in Europe until the twelfth century.

The essential ingredient of paper is cellulose fibre, although some modern papers contain mineral and synthetic fibres. Cellulose occurs in nature and, together with a substance called lignin, provides the structural support for all plants, from grasses to trees. Until the nineteenth century the only source of fibre for paper was cotton and linen rags. These rags were beaten with water into a pulp. The papermaker placed a tray of crossed wires into the mixture, allowing a thin layer of fibres to settle on the top. When turned out, pressed between blankets and dried, the result was a sheet having the quality of blotting paper. In order to make this surface suitable for drawing or printing upon, it had to be coated with a gelatine or starch size.

There are two main types of paper: 'laid' paper shows the pattern of the vertical 'wire-marks' and the horizontal connecting 'chain-lines' of the wires in the papermaker's tray. 'Wove' paper is made from a tray with a wire mesh which is so tightly woven that it often leaves no marks visible. It was developed in about 1755 to produce a smoother surface than that offered by laid paper, but it was not widely used until about 1790.

At the beginning of the nineteenth century wood began to replace rags as

the source of fibre for paper. This often resulted in papers which were brittle and which discoloured quickly, largely because the lignin which was left in unrefined wood-pulp paper during manufacture had a tendency to oxidise, causing the paper to become acidic. Chemical treatments involving bleach were introduced to remove the lignin, which could bring about an improvement in paper quality.

In order to obtain the desired smoothness of surface, sheets of paper are pressed. Traditionally for hand-made papers there are three grades of finish: HP (hot pressed), NOT (i.e. not hot pressed) and rough. Special sorts of 'art' paper are coated with chalk to provide a smooth surface for printing.

PARCHMENT

A support for writing and less frequently for drawing in the Middle Ages and occasionally later, made from the skins of animals, usually sheep or goats. 'Vellum' was a finer quality parchment made from specially selected young skins. In order to make the surface smooth it was rubbed with pumice, chalk or ground bone.

Parchment and vellum were chiefly used before PAPER was readily available, although some later artists made use of them on account of the rich effects and fineness of line which could be obtained.

PASTEL

See CHALK (fabricated chalks).

PEN

(Latin *penna* = feather.) Over the centuries six basic types of pens have been developed. These are:

The reed pen. Cut from fine canes and bamboo-like grasses, this is the oldest type of pen, first used for writing and not employed as a drawing instrument until the Renaissance. It was capable of great variation of width of line depending on the way it was held, and was much favoured by Rembrandt in the seventeenth century and Van Gogh in the nineteenth, among many other exponents.

The quill pen. Usually cut from the large, hollow outer wing feathers of the goose or swan, but feathers from crows, eagles or turkeys were also suitable. The plucked feathers were soft at the shaft end and were cured or hardened by being placed in pots of hot sand before being cut as quills. The point of the quill gave great flexibility of line, which made it a popular instrument for artists from the fifteenth century to the end of the nineteenth.

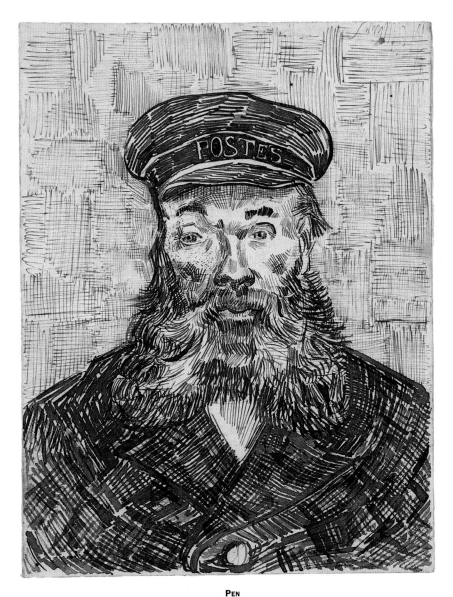

PEN
Vincent van Gogh (1853–90): *Portrait of Joseph Roulin*, 1888. Reed and quill pen and
brown ink and black chalk, 320 × 244 mm (12⅝ × 9⅝ in). JPGM, 85.GA.299.

The metal pen. The metal pen succeeded the quill as a writing instrument in
the later nineteenth century and soon replaced it as one for drawing. It was
essentially a wooden holder into which a variety of metal nibs could be
inserted. Such pens were often called 'dip' pens because they demanded
constant refilling or 'dipping'. The advantages of the metal pen over the quill

were the great variety of shapes of nib which were available and its ability to withstand hard wear. It also tended to produce fewer blots than a quill.

The fountain pen. A writing instrument invented in the nineteenth century and still in use today. It differs from the simple metal or dip pen in containing its own reservoir of ink.

The ballpoint pen. In 1939 Laszlo Jozef Biró patented a device which uses viscous ink in an open-ended capillary tube. His pen contains a replaceable ink reservoir filled with a viscous liquid of either spirit-soluble or oil-soluble dyes. The ink is transferred to the paper not by a nib but by a 'ball point'. Although the ballpoint is suitable for drawing because of its flexibility and smoothness, many of the dyes used in ballpoint ink fade rapidly.

The felt tip/nylon tip pen. Flexible modern drawing and writing instruments in which the ink flow is controlled by a tip of felt or a bundle of nylon fibres in place of a conventional nib. Their chief drawback is that the ink leaves a penetrating stain which cannot be removed.

PENCIL

The early meaning of 'pencil' – found in Latin as *pencillus* and Old French as *pincel* – was an artist's paint BRUSH of camel hair, fitch, sable or some other similar material. By the early seventeenth century the term seems to have come to mean instead an instrument for writing or drawing made to hold GRAPHITE, white or coloured CHALK or CHARCOAL. By the middle of the century the meaning changed once more to denote more specifically a strip of graphite enclosed in a cylinder of soft wood, or in a metal case with a tapering end (a '*porte-crayon*'). It is this meaning which is generally understood today.

The term 'lead' pencil is a misnomer which has arisen from the shortening of the term 'black lead' which was the original name for graphite. This is not to be confused with LEAD POINT.

Graphite pencils were not widely employed until the eighteenth century and only became really popular in the 1790s and early 1800s when it became increasingly difficult to obtain good natural black chalks. A graphite pencil leaves a shiny deposit on the paper, while black chalk (with which it is sometimes confused) leaves a duller deposit as well as being more consistently grey in tone.

PENTIMENTO

(Italian: alteration/change of mind.) A term applied to both paintings and drawings to refer to visible corrections made by the artist in the course of his work. '*Repentir*' is another term which is occasionally found.

PHOTOMECHANICAL REPRODUCTIVE PROCESSES

The term 'photomechanical' covers any process by which an image is photographically transferred onto a printing surface. A variety of such techniques have been developed for surfaces to be printed by RELIEF, INTAGLIO or 'planographic' (i.e. using a flat surface) processes. The standard relief process uses the 'line block' and the 'half-tone block'; the intaglio process is called 'photogravure', and there are two planographic processes, 'photolithography' and 'collotype'. Their complexity forbids any description in a work of this length, but with the exception of collotype they involve the use of a half-tone screen for reproducing graduated tones and colours. The screen breaks up the image into a series of dots of varying size, which are an unmistakable sign of photomechanical reproduction. In recent years, with the increase of interest in photographic and commercial imagery, artists have often incorporated photomechanically reproduced imagery into their prints.

PLATE-MARK

The mark made by the edges of an INTAGLIO plate where it is forced into the paper when run through the press.

POCHOIR

The French for a stencil. The term is applied to a class of print usually hand-coloured through a series of carefully cut stencils. This process was much used in Paris during the early decades of the twentieth century.

POUNCE

A fine powder used in the transference of the principal outlines of a drawing, usually a CARTOON, to another support such as a wall or another sheet of paper. Small prick-holes were made in the paper along the lines, and dust

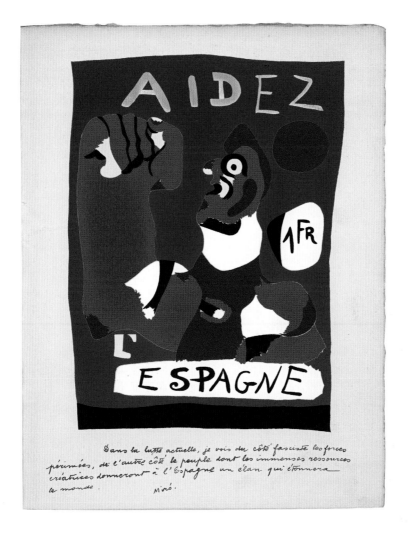

POCHOIR
Joan Miró (1893–1983): *Aidez L'Espagne – Help Spain*, 1937.
Colour stencil (*pochoir*) with the artist's lithographed text below.
247 × 190 mm, irreg. (9¾ × 7½ in). BM, 1981–6–20–44.

(usually from pumice) was 'pounced' or rubbed through these holes, leaving a dotted outline of the design on the surface beneath.

PRESENTATION DRAWING

This term was coined by the German art-historian Johannes Wilde in the early 1950s to define some highly finished drawings made by Michelangelo as gifts for close friends and which the artist regarded as works of art in their own

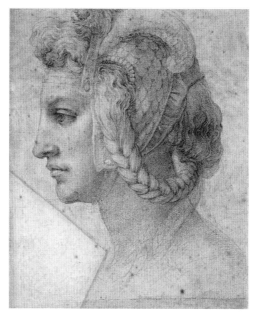

right. The expression is now used to describe many other finished drawings which are not preparatory for other works.

PRESSES

Each of the four main types of printing process requires a different sort of press. An INTAGLIO press works on a similar principle to the old-fashioned clothes-mangle: a sliding bed passes horizontally between two rollers as the operator turns the wheel. The inked plate is placed face upwards on the bed of the press, a sheet of dampened paper is put on top of it, and several specially resilient blankets (to spread the pressure evenly) are laid over both. As the bed passes between the roller, the paper is forced into the grooves in the plate and drags out the ink.

In RELIEF PRINTING the surface of the block is inked, using a dabber or (from the early nineteenth century onwards) a roller; the printing INK has to be of a stiff consistency in order to remain on the raised parts of the block and not flow into the hollows. The printing is done in a press which works on the same principle as an ordinary type-printing press; pressure is applied uniformly and vertically but need only be light.

In LITHOGRAPHY a flat-bed 'scraper press' is generally used. The paper is

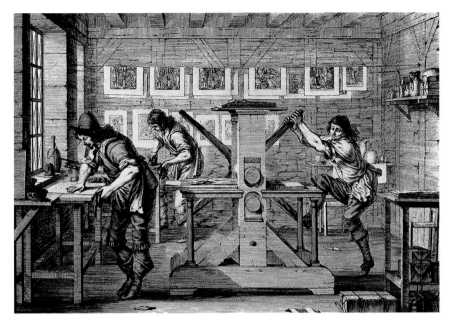

PRESSES
Abraham Bosse (1602–76): *Intaglio Printing,* 1642.
Etching, 254 × 321 mm (10 × 12⅝ in). BM, R.8–15.

laid face down on the inked stone, and rubbed along the back to transfer the ink. For SCREENPRINTING see the separate entry.

PROOF

A true proof is an impression taken before work on the block or plate is complete. These are known as 'working' or 'trial' proofs, or, if corrected by hand by the artist, 'touched' proofs. From at least the eighteenth century, 'proofs before letters' (proofs taken before the engraved LETTERING was added) were deliberately printed to be sold to collectors at a higher price, as was also done in the nineteenth century with ARTIST'S PROOFS, REMARQUE PROOFS and 'open letter proofs' (proofs in which the outlines only of the engraved lettering appear, before these were hatched or shaded in). A twentieth-century development is 'printer's proofs'. The term 'proof' is also often loosely and misleadingly used as a synonym for IMPRESSION.

RECTO

The front, or more fully worked, face of a sheet drawn on on both sides. Also the right-hand page of an opening in a bound volume, irrespective of which, if any, side is drawn on. The other side is the VERSO.

RELIEF PRINTING

The method of printing used for WOODCUT, WOOD-ENGRAVING and METALCUT. For a description of the process see PRESSES.

REMARQUE

Originally a sketch made by the artist on the margin of an etched plate and often unrelated to the main composition. The practice was begun in the seventeenth century as a means of testing the strength of etching acid on a plate before risking the biting of the main design, and was normally burnished out before printing the final edition. In the nineteenth century, 'remarque proofs', in which the remarque served no purpose at all, were specially created as a method of multiplying artificial rarities for collectors.

RELIEF PRINTING
Jost Amman (1539–91): *The Printer*, 1568. Woodcut, 79 × 60 mm (3⅛ × 2⅜ in). BM, 159.d.11, 1904-2-6-103(20).

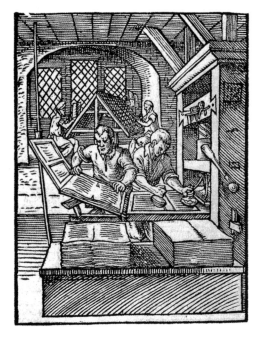

RETROUSSAGE

A refinement of INTAGLIO printing used to achieve a softening and more atmospheric effect. Fine muslin, passed lightly over the surface of an inked and wiped plate, catches a small amount of the ink in the lines and draws it slightly upwards; these traces of ink at the side of the lines cause them to lose some of their sharpness of definition when printed.

REMARQUE
David Law (1831–1901): A remarque placed below the margin but within the plate-mark of a marine etching dated 1881. BM, 1881-11-12-2001.

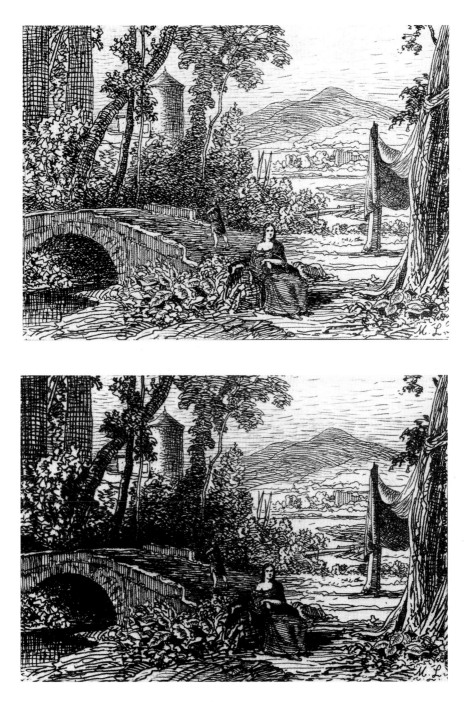

RETROUSSAGE

Maxime Lalanne (1827–86): *Copy after Claude* (detail), 1886. Etching, 184 × 120 mm (7¼ × 4¾ in). Two impressions from the same plate. The first has been clean wiped; the second has been printed with heavy retroussage, which has dragged some of the ink out of the lines. BM, LLL.2.3, 1881–7–9–784 and 785.

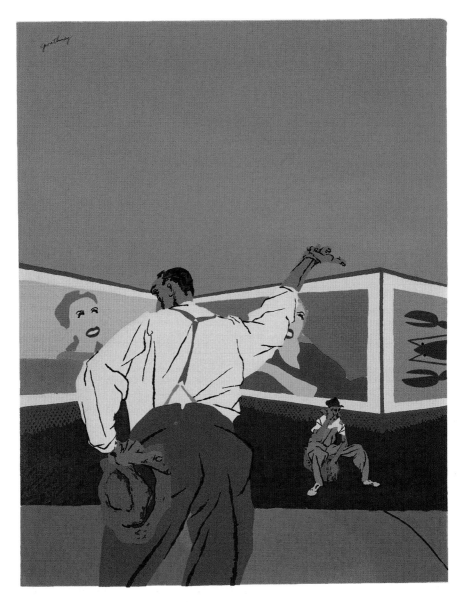

SCREENPRINT
Robert Gwathmey (1903–88): *Hitch-Hiker*. Screenprint in colours,
427 × 332 mm (16¹³⁄₁₆ × 13¹⁄₁₆ in). BM, 1981-7-25-14.

ROULETTE

A wheeled tool used in some of the dot processes, first mentioned in connection with MEZZOTINT but used largely in CRAYON MANNER and STIPPLE ENGRAVING in the eighteenth century.

SCRAPING/SCRATCHING OUT

The removal of pigment with a knife, pointed instrument or even a fingernail. This can be done to make corrections, but also became a popular technique with nineteenth-century watercolourists, who used it to expose the paper in order to produce a white highlight. See also HEIGHTENING.

SCREENPRINTING

A variety of stencil printing. A gauze screen, fixed tautly on a rectangular wooden frame, is laid directly on top of a sheet of paper. Printing INK is spread over the upper side of the mesh and forced through it with a squeegee (a rubber blade) so that it transfers to the paper on the other side. The screen is usually of silk (in America the process is usually called 'silk-screen' or 'serigraphy'), but it can be a cotton, nylon or metal mesh. The design is applied to the screen in various ways. One is to cut a stencil of paper and attach it to the underside of the screen; another is to paint out areas of the screen with a liquid that sets and blocks the holes in the mesh.

Screenprinting began to be used by artists in America in the 1930s and owed its early popularity to its simplicity and cheapness. One important development in the 1960s was the use of photostencils, which allow the artist to incorporate photographic images into the print. A screenprint can often be distinguished from a LITHOGRAPH (the process most similar to it) by the wove pattern of the screen which is impressed into the surface of the ink, or by the heavy charge of ink transferred to the paper.

SIGNATURE

Although some German drawings of the sixteenth century bear artists' MONOGRAMS, the practice of signing drawings in manuscript did not become general before the eighteenth century, and has never become universal. Although many prints bear signatures etched on the plate, the practice of signing individual impressions by hand scarcely occurs before the mid-nineteenth century.

Many names found written on Old Master drawings are not signatures but ATTRIBUTIONS, INSCRIBED by later collectors or dealers. Such attributions may be accurate, but often are not. Purported 'signatures' have sometimes been added to drawings with fraudulent intent to increase their value.

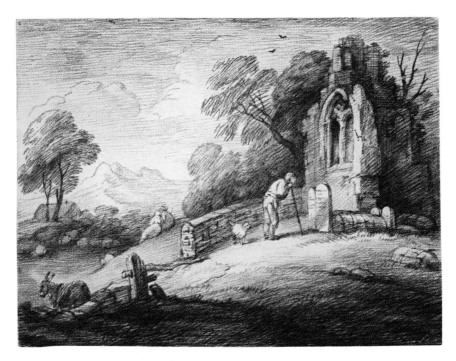

SINOPIA

A reddish-coloured pigment derived from sinopite, which is a ferruginous clayey earth of brick-red colour. Before a FRESCO was painted, an outline of the composition was drawn with the brush in sinopia on the wall or ceiling. This outline was first drawn in CHARCOAL and then the artist would go over the lines with a small pointed brush dipped in a thin solution of ochre, which left only a slight mark. Then he removed the charcoal with a brush of feathers – '*un mazzo di penne*' – and the ochre was reinforced with sinopia red.

These drawings, which are called *sinopie* after the pigment in which they were made, were covered when the plaster was applied for frescoing and have only come to light in recent years when some frescoes and their plaster supports have been detached from walls or ceilings, usually for conservation reasons. *Sinopie* are of great importance because they show the master's earlier ideas for the composition, and are often of great beauty in their own right.

Soft-ground etching

A variety of ETCHING which can be used to imitate a PENCIL or CHALK drawing. The soft ground laid on the plate is a mixture of ordinary etching ground and tallow. The etcher draws on a piece of thin paper placed over the ground. When the paper is removed, the ground adheres to the paper where the drawing instrument was pressed, so that the granular effect of the pencil or chalk is reproduced when the plate is bitten.

A soft-ground etching can usually be distinguished from a LITHOGRAPH, with which it is most likely to be confused, by the presence of a PLATE-MARK, or by the ink standing in slight relief as is characteristic of INTAGLIO processes. Soft-ground etching was invented in the 1770s as a method of multiplying drawings, and has in the twentieth century and today again become widely used because of the variety of textures (such as textiles) that can be pressed into the ground.

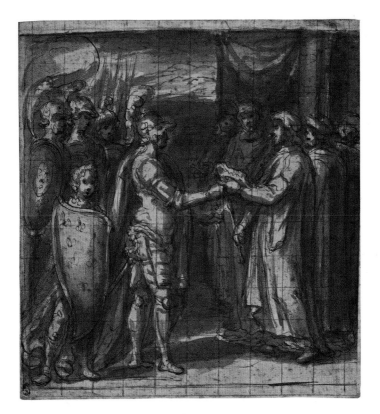

Squaring

Taddeo Zuccaro (1529–66): *Scene from the History of the Farnese Family*, 1563–5.
Black chalk, pen and brown ink and wash, squared for transfer in red chalk,
302 × 275 mm (11⅞ × 10⅞ in). JPGM, 87.GG.52.

SQUARING

A technique to facilitate the enlargement (or occasionally the reduction) of a design. A grid containing an equal number of squares is ruled on the original drawing and on the surface destined for the enlarged design. The design is then transferred square by square.

STATE

In the process of making a print an artist often takes a few PROOFS at different stages of his working to check progress. Any impression which shows additional working on the plate constitutes a 'state'. States are usually created by the printmaker himself; but later additions (such as the address of a later publisher or the reworking of a plate at a later date) also create new states. Most catalogues of prints are primarily devoted to describing the changes of state that occurred during the printing of an image.

STEEL ENGRAVING

Steel is very hard to engrave, so the term rather confusingly refers to prints which are almost entirely etched, although the lines are laid in the regular manner of an ENGRAVING.

STEEL-FACING

A process patented in 1857 (although similar processes had been in use for some decades) whereby an extremely thin coating of steel is deposited by electrolysis on a copper plate. This revolutionised the print business and created a new market for illustrated books and popular magazines because plates no longer became worn. If the steel did wear out, another layer could be added, and at any time the steel could be removed simply by reversing the electric current.

STIPPLE ENGRAVING

An INTAGLIO tone process in which the tone is produced by a profusion of tiny dots, sometimes engraved, but usually etched. Stipple engraving flourished in England during the late eighteenth century, where one of its leading exponents was the Italian-born Francesco Bartolozzi (1727-1815). Stipple engravings were frequently printed in colour.

STUMP

A coil of leather, felt or paper with blunt points at both ends, which was used for rubbing on CHALK, PENCIL, PASTEL and CHARCOAL drawings in order to produce a softer appearance.

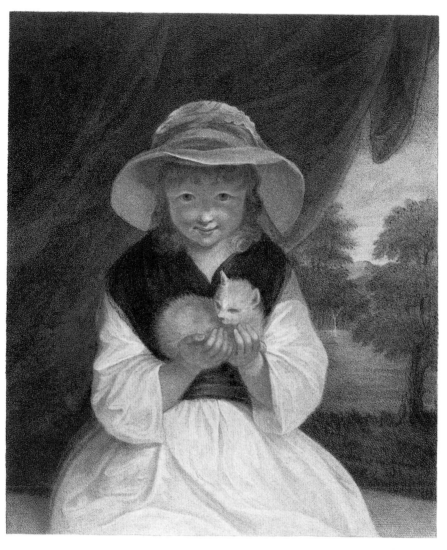

STIPPLE ENGRAVING
Francesco Bartolozzi (1727–1815) after Sir Joshua Reynolds (1723–92):
The Girl and Kitten, 1787. Stipple engraving printed in colours with some
hand colouring, 261 × 185 mm (10¼ × 7¼ in). BM, 1831–12–12–19.

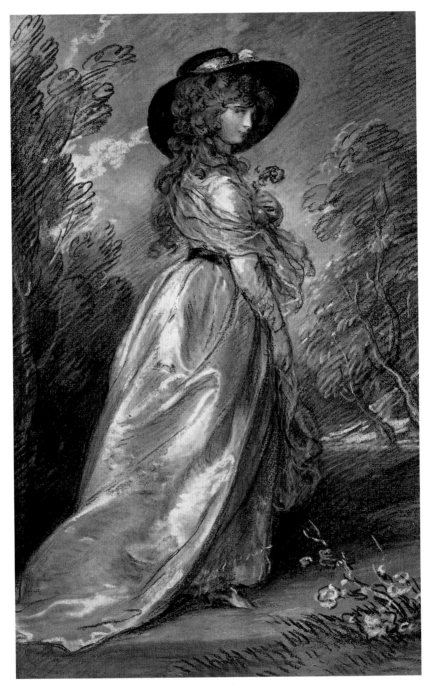

STUMP

Thomas Gainsborough (1727–88): *Study of a Woman* (perhaps for *The Richmond Water-Walk*), *c.*1785. Black chalk and stump, heightened with white bodycolour on buff paper, 491 × 311 mm (19⁹⁄₁₆ × 12¼ in). BM, 1910–2–12–250 (Salting).

STYLUS

A drawing instrument usually made of cast metal, with a point often at either end. Unlike METALPOINT or LEAD POINT, it was used only to impress lines into paper and was frequently employed by artists when beginning to work out a composition, in order to avoid the need to rub out incorrect lines. It was also used as a method of transferring the main lines of a composition drawing, as, for example, from a sheet of paper to a copper plate in preparing for ETCHING, or from a CARTOON to the plaster in the case of a FRESCO. The artist could see the 'blind' lines he was making in the paper by holding the sheet at an angle to the light.

SURFACE TONE

Tone created in an INTAGLIO print by leaving films of ink on the plate in the wiping. This can be accidental, but certain artists, notably Rembrandt, deliberately created great variations in design and atmosphere by carefully controlling the amounts of ink left on different parts of the plate.

TEMPERA (DISTEMPER)

A method of painting in which dry colours are made usable by mixing them with some glutinous substance soluble in water, usually on a ground of chalk or plaster mixed with gum. The term is also applied to the pigments and to the ground.

The standard tempera vehicle is a natural emulsion of egg yolk thinned with water. The egg yolk helps the colour to adhere to the support.

By the thirteenth century in Italy a sophisticated technique of painting in tempera on wood panels had emerged, and it reached its greatest artistic heights in the fifteenth and early sixteenth centuries in the hands of such artists as Fra Angelico and Botticelli. Tempera painting was gradually supplanted by oil painting, but the technique was revived in the late nineteenth century in Europe and the United States. Tempera was often used in the production of wallpaper.

TRANSFERRING

The transference of a design from one surface to another: for the various methods, see POUNCE, SQUARING, OFFSET, COUNTERPROOF, STYLUS, CARTOON.

TRANSFER-LITHOGRAPHY

A LITHOGRAPHIC process in which the artist draws his image on specially prepared transfer paper, from which it is transferred to the stone and then printed in the usual manner.

VERSO

The opposite of RECTO, i.e. the 'back' of a sheet or the left-hand page of an open volume.

VIGNETTE

A small ornamental engraving or design chiefly used in book illustration. Its essential feature is that it has no defined border (the edges shading off into the surrounding paper). When a vignette occurs at the end of a passage, it can be called a 'tail-piece' or a '*cul-de-lampe*'.

WASH

When used in connection with WATERCOLOUR, this term denotes a covering with a broad layer of colour by a continuous movement of the brush. When applied to INK drawings the term often means the use of a dilute ink, but pen drawings are also frequently washed with a different colour, for instance pen and brown ink with grey wash.

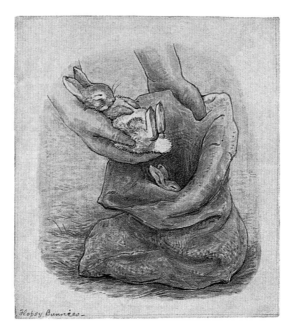

VIGNETTE
Beatrix Potter (1866–1943): Illustration for page 41 of
The Tale of the Flopsy Bunnies (1909). Pen, ink and watercolour,
83 × 75 mm (3¼ × 2¹⁵⁄₁₆ in). BM, 1946–11–21–14.

WASH

Giovanni Battista Tiepolo (1696–1770): *Flight into Egypt*, 1725–35. Pen, brown ink and brown wash over black chalk, 304 × 453 mm (12 × 17⅞ in). JPGM, 85.GG.409.

WATERCOLOUR

John Robert Cozens (1752–97): *From the Road between the Lake of Thun and Unterseen.* Watercolour, 237 × 365 mm (9⁵⁄₁₆ × 14⅜ in). BM, 1910-2-12-242.

WATERCOLOUR

Strictly a pigment for which water and not oil is used as a medium, and GUM ARABIC added as a binder.

A watercolour wash is a liquid composed of water in which particles of colour brushed from cakes of pigment are suspended. It must remain in a liquid state long enough for the tiny fragments of colour to distribute themselves evenly across the paper.

The brilliancy of pure watercolour occurs because its translucent nature allows the white surface of the paper to be used as the lighting agent. Most watercolour papers have a granular surface and the little hollows and projections provide an alternation of light and half-light. Watercolour is sometimes mixed with white pigments to render it opaque (see BODYCOLOUR and GOUACHE).

The watercolour technique was in use on papyrus rolls in ancient Egypt and on vellum manuscripts in medieval Europe. Dürer was one of the first artists to employ watercolour as a medium in its own right, but despite its occasional use by others in the intervening years (notably Rubens and Van Dyck), the technique did not become fully developed until the eighteenth century in England, in the hands of artists such as Paul Sandby and J. R. Cozens.

WATERMARK
A watermark used by the English firm of James Whatman, working 1760–1850.

WATERMARKS

Devices used by paper manufacturers, the earliest being found in Italian paper of the late thirteenth century. The device is made of wire and sewn onto the mould (see PAPER); it leaves an impression on the paper by making it thinner and hence more translucent. Watermarks can usually be easily seen when the sheet is held up to the light. Indications of the date and area of origin of the paper can often be deduced from the watermark by consulting one of the many dictionaries of watermarks that have been compiled.

'Countermarks' are smaller, subsidiary watermarks often found in addition to the main watermark on papers after about 1670. They generally consist of the maker's initials and are usually placed parallel to the main watermark in the centre of the opposite half of a double-folio sheet.

WOODCUT

Historically the most important of the RELIEF PRINTING processes. The design is drawn directly on the surface of the wood block which is cut parallel to the grain ('plank' as opposed to 'end-grain'). The parts which are to print white are cut away, leaving the black lines in relief. The tool used is usually a knife

WOOD-ENGRAVING

Joseph Swain (1820–1909) after Frederick Sandys (1832–1904): *Amor Mundi*, 1865.
Wood-engraving, 175 × 99 mm (6⅞ × 3⅞ in). BM, 1912–12–27–182.

(see ENGRAVING). The block is then printed on a relief press (see PRESSES).

Printing from woodblocks was known in Europe as early as the twelfth century, but originally only for stamping designs on textiles. The earliest surviving prints on paper cannot be dated before the last years of the fourteenth century. Since woodblocks can be printed together with type, this was for many years the favoured method of book illustration.

WOODCUT
Enlarged detail.

WOOD-ENGRAVING

A version of WOODCUT developed in the eighteenth century. A very hard wood is used (usually boxwood), which is always cut across the grain. The tool used is a version of the 'burin' or 'graver' (see ENGRAVING), the handle of which is held against the palm and the blade pushed before the hand, making a clean incision into the wood.

Wood-engravings are printed in RELIEF (not in INTAGLIO) in the same way as woodcuts. The wood-engraver is able to produce much more detailed work than the woodcutter and characteristically achieves an effect of closely worked lines that print white against black (the normal woodcut is seen as black lines against white).

Thomas Bewick of Newcastle (1753–1828) was the first great exponent of wood-engraving, which was much used in the nineteenth century for book illustration.

WOOD-ENGRAVING
Enlarged detail.

Appendix
Care of works on paper

Although prints and drawings regularly survive over considerable periods of time, it is prudent to assume that they are essentially more fragile than they initially appear. The chief enemies of works on paper are as follows:

Light
Light (especially sunlight) and ultra violet (UV) can both not only weaken the cellulose fibres in paper but will also fade colours and pigments (especially watercolours), usually irreversibly. The old joke about only looking at watercolours in the dark has more than a modicum of truth about it. Ideally, works on paper should be hung in unlit corridors or shady corners. When this is not feasible a curtain hung over the work will protect it.

Heat
Heat damages the cellulose in paper and, when combined with moisture, can encourage the growth of mould. Framed prints and drawings should not be placed above radiators, since the warm currents of air produced can draw dust and dirt up onto the work.

Insects
Various insects, notably wood-boring beetles, silverfish and thrips, can creep into framed works on paper and do damage. If they perish on the surface of a picture they can leave a stain that proves difficult to remove.

Human agency
Much of the damage done to works on paper is the result of thoughtless mounting, notably in the use of poor-quality acidic boards which leave a residual mark on the sheet over time. This shows as an orange/brown discoloration on the bevel where it has been cut around the aperture. The staining which is revealed when an old mount is removed is almost impossible to reduce or hide. Self-adhesive tape similarly leaves marks which can rarely be entirely eradicated.

Always insist on conservation quality acid-free mounting boards (sometimes called 'museum' boards) to ensure works are correctly mounted and, when considering cleaning or repair, only entrust works to those with a recognised qualification in the conservation of works on paper.

Unmounted prints and drawings may be safely stored between acid-free tissue, flat in archival solander boxes. Use both hands when holding such items and ensure that they are clean and dry. A fold in a sheet of paper can easily become a tear if the work is casually handled. Regular monitoring of both framed and unframed items should ensure that potential problems are spotted before they become too serious.

Select Bibliography

The British Museum Press has also published *Prints and Printmaking* by Antony Griffiths (1980; 2nd edn 1996, revised reprint 2004), which includes fuller accounts of printmaking processes and short historical notes as well as a bibliography. The contents and workings of the British Museum's Department of Prints and Drawings are dealt with in *The Department of Prints and Drawings in the British Museum – User's Guide*, by Antony Griffiths and Reginald Williams (1987). A survey of the collection of drawings was given by A.E. Popham in *A Handbook to the Drawings and Water-colours in the Department of Prints and Drawings, British Museum* (1939).

The following bibliography is confined to a few standard works which are particularly helpful.

Technical

BRUNNER, FELIX, *A Handbook of Graphic Reproduction Processes*, Teufen, Arthur Niggli Ltd, 1962; 4th edition, London, Alec Tiranti, 1972.

COHN, M.B., *Wash and Gouache: A Study of the Development of Materials of Watercolor*, Cambridge (Mass.), Fogg Art Museum, Harvard University, 1977.

GASCOIGNE, BAMBER, *How to Identify Prints: A complete guide to manual and mechanical processes from woodcut to inkjet*, London, Thames and Hudson, 1986 (and subsequent editions).

HUNTER, DARD, *Papermaking: The history and technique of an ancient craft*, New York, Alfred A. Knopf, 1943; 2nd edn, New York, Dover Publications, 1978.

IVINS, W.M., *How Prints Look*, New York, Metropolitan Museum of Art, 1943 (and subsequent editions).

LAMBERT, SUSAN, *Drawing: Technique and purpose*, London, Victoria and Albert Museum, 1981.

WATROUS, JAMES, *The Craft of Old Master Drawings*, Madison, University of Wisconsin Press, 1957.

WEEKES, URSULA, *Techniques of Drawing from the 15th to the 19th Centuries*, Oxford, Ashmolean Museum, 1999.

Historical

GODFREY, RICHARD, *Printmaking in Britain: A general history from its beginnings to the present day*, Oxford, Phaidon Press, 1978.

HARDIE, MARTIN, *Watercolour Painting in Britain*, 3 vols, London, B.T. Batsford, 1966-8.

HIND, A.M., *A History of Engraving and Etching from the 15th Century to the Year 1914*, 3rd edn, London, Constable, 1923; New York, Dover Publications, 1963.

LANDAU, DAVID, AND PARSHALL, PETER, *The Renaissance Print 1470-1550*, New Haven and London, Yale University Press, 1994.

MEDER, JOSEPH, *The Mastery of Drawing*, translated and revised by Winslow Ames, New York, Abaris Books, 1978.

WHALE, GEORGE, AND BARFIELD, NAREN, *Digital Printmaking*, London, A. and C. Black, 2001.

Index